This Book Belongs To

(Name of graduate goes here)

Using a No. 2 pencil, fill in your last name first, followed by your first name (for instance: Boragart, Gerald III)

FAMILY GUY

The Stewie Griffin School of Hard Knocks

Grad Pad

A Personalized, Ultra-Confidential Yearbook

by Stewie Griffin

Based on the series by Seth MacFarlane

HARPER ENTERTAINMENT

NEW YORK · LONDON · TORONTO · SYDNEY

This book would not be possible without Debbie Olshan's school spirit, Hope Innelli's desire to return to her roots as a yearbook editor, Andrew Goldberg's skills as Tutor of Advanced Humor, or the incomparable genius of the Dean of Comedy himself, Seth MacFarlane.

—THE PUBLISHER

Once again I have no one to thank but myself.

—S. G. (THE AUTHOR)

HARPER ENTERTAINMENT

FAMILY GUY: THE STEWIE GRIFFIN SCHOOL OF HARD KNOCKS GRAD PAD.
Copyright © 2007 by Twentieth Century Fox. All rights reserved. Printed in the United States of America. No part of this book may be used or reproduced in any manner whatsoever without written permission except in the case of brief quotations embodied in critical articles and reviews. For information address HarperCollins Publishers, 10 East 53rd Street, New York, NY 10022.

HarperCollins books may be purchased for educational, business, or sales promotional use. For information please write: Special Markets Department, HarperCollins Publishers, 10 East 53rd Street, New York, NY 10022.

FIRST EDITION

Designed by Timothy Shaner, nightanddaydesign.biz

Printed on acid-free paper

Library of Congress Cataloging-in-Publication Data is available upon request.

ISBN: 978-0-06-114869-9
ISBN-10: 0-06-114869-5

07 08 09 10 11 ❖ 10 9 8 7 6 5 4 3 2

Introduction

Greetings Once Again Loyal Minions:

Since the publication of my first book, *Stewie's Guide to World Domination*, I am pleased to report that my army has grown at an astounding rate, and my death squad has shown surprising restraint in not raping and pillaging the countryside—so, kudos to them.

The most studious among you are no doubt ruling over your individual provinces with a level of proficiency and cruelty surpassed only by yours truly. Hence, your graduation from high school, college, Apex Tech, or whatever trade school has recently awarded you a Xeroxed diploma and a free set of power tools. (I'm not judging, by the way. The world needs refrigerator repairmen and Zamboni drivers, too.)

This little tome is an opportunity for you and your cronies to capture this one pure moment in time. For those of you graduating high school, it's the moment when your life at home ends and your experimentation with narcotics and homosexuality begins. For those of you graduating college, it's the moment when your experimentation with narcotics and homosexuality ends and your sad, pathetic workaday existence (complete with Geo Metro and a boss with offensively bad coffee-breath) begins. And for those of you graduating Apex Tech, it's the moment when your apprenticeship in combination welding technology ends and your lifelong battle with Milwaukee's Best and plumber's butt begins.

But, before all that, take a moment to write down your thoughts, your memories, and your dreams. **And don't be afraid to weep a little on these pages—your tears sustain me.** And, finally, I invite you to paste pictures of yourself and your chums amidst my inspirational thoughts and the photos of my own family (as unsightly as they may be), because, after all, this is your book. I only ask one thing: do not include any pictures of Justin Timberlake. I simply can't stomach that kid. He's mangy, vain, smug, and has a wholly unjustified sense of self-accomplishment. Plus, I've heard that when he's unable to fall asleep, he sings himself to sleep, which is the act of a real douche.

So, what the devil are you waiting for? Unleash the memories and let your postgraduate life (and my royalty checks) begin!

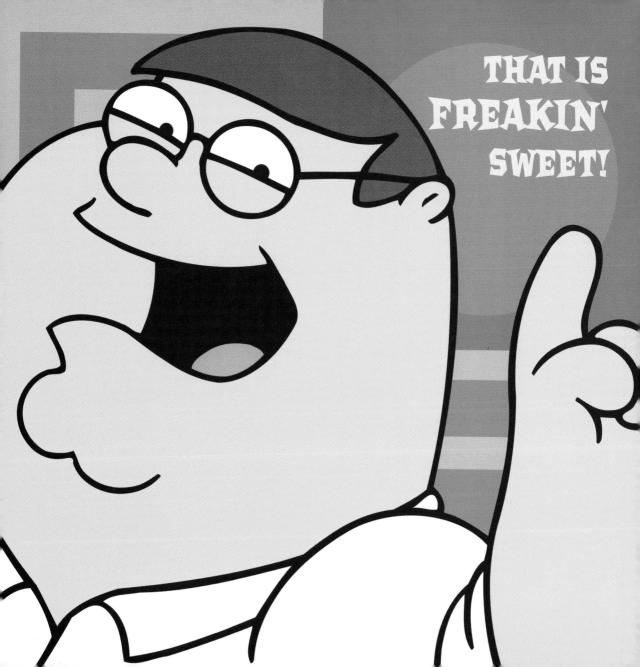

Fondest Memories

(Tickle fights with Rupert)

1. _____

2. _____

3. _____

4. _____

5. *(If you have that many!)* _____

Worst Memories

(The Fat Man's twisted attempt to breastfeed me)

10. _____

9. _____

8. _____

7. _____

6. _____

5. _____

4. _____

3. _____

2. _____

1. _____

Most Pee-Worthy Memories

(When I tripped Lois and she cracked a rib on the coffee table. That was hilarious!)

Memories of Spring Break

(Such as pounding Jäger shots with your bros or accidentally humping a street urchin in Guadalajara)

(Your photo goes here)

(Your photo goes here)

(Your photo goes here)

Favorite Drinking Chums

(Like Norman, your buddy who scorched his sphincter while trying to light his farts on fire)

Favorite Watering Holes

Favorite Brews

Good lord! Some of these skeezes make Christina Aguilera look like Gidget!

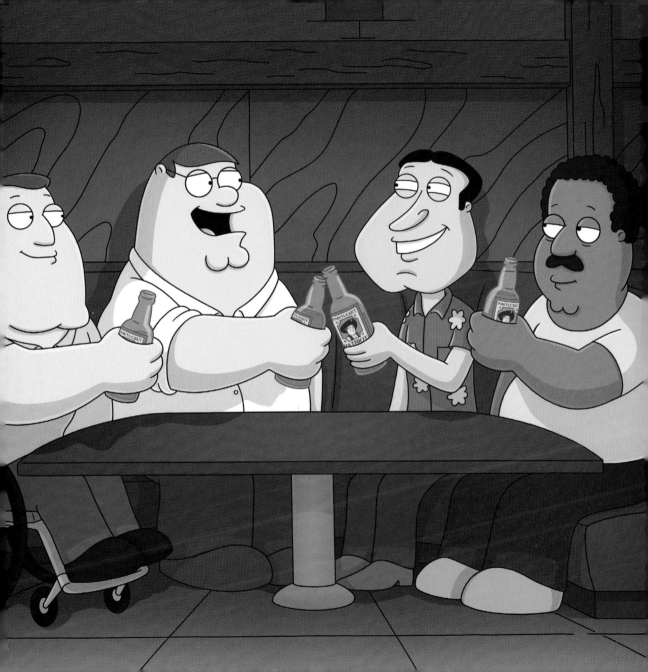

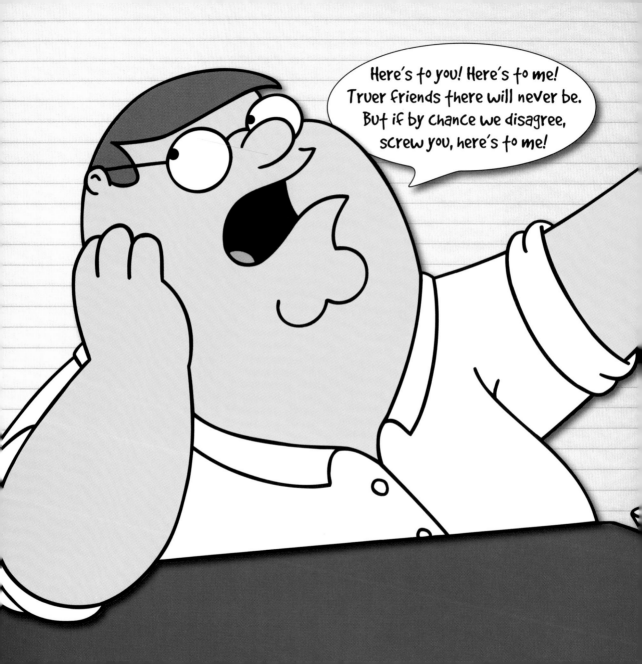

This Page Is Reserved for BFF's Only

(So, if you're not a BFF, piss off)

19

Class Officers

President _____
(Vacuous narcissist)

Vice President _____
(Drooling lackey)

Treasurer _____
(Tightwad)

Secretary _____
(Glorified stenographer)

Newspaper Editor _____
(Andrea Zuckerman wannabe)

Yearbook Editor _____
(Total raging bitch)

Twenty bucks says all these future-degenerates of America are indicted by the age of thirty-three. Twenty more bucks says the class treasurer is a real hit in prison.

QUAHOG 5 NEWS

COVERING QUAHOG
LIKE A WET BLANKET!

Biggest News Events of the Year

In School/On Campus

(Norman's anal inferno should fit in right about here)

National

("Condi Rice and Vince Vaughn! The Beltway's hottest new couple!")

Worldwide

("Stewie's army advances! [Death squad shows surprising restraint in not raping and pillaging the countryside.]")

Worst Cafeteria Meals

(Can't be worse than Lois'
beef stroganoff. Blech!) _____

Best Cafeteria Meals

(PB&J with the crusts
cut off! Thoughtful!) _____

Enter Freshman
Weight Gain
Here If You Dare _____

(Wow. That's, uh . . . I don't want to seem rude,
but you're not going to eat this book? Are you?)

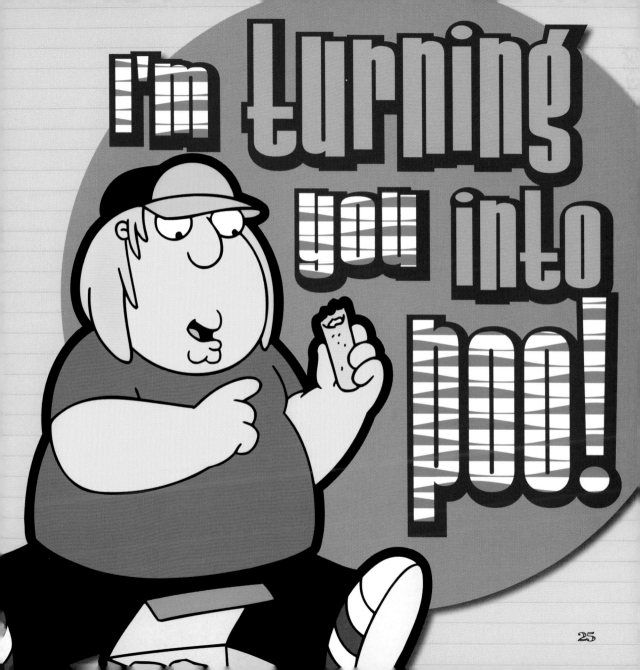

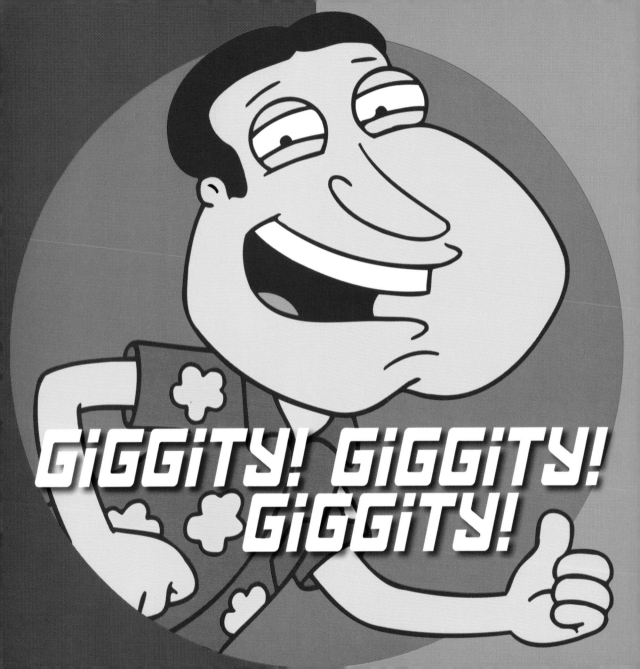

Best Giggity-Giggity Moments

(Oh, come on. Who gave Captain Syphilis a page?)

Hic-A-Doo-La Girl of the Year

(What the bloody hell does that mean?) _____

Hic-A-Doo-La Boy of the Year

(Oh, that's easy. Jesse Metcalfe.) _____

Homecoming King and Queen

(How about me and Shirley Blitt?) _____

Best Dressed

(I've always been fond of Moammar Khadafi's fashion taste)

Worst Dressed

(Are we counting Saddam? I mean, Good Lord, did you see what he was wearing in that hole? I know it was a hole, but if there's a chance you're going to be on international television, you might want to put on some slacks. Or at least run a comb through your hair.)

I'd love to stay and chat, but you're a total bitch.

Ms. Congeniality

(I'm assuming this is code for "slut," right?)

Mr. Congeniality

(It's a three-way tie between Zack Morris,
Seth Cohen, and Duckie Dale!)

Class Clown

(Jimmy Fallon! Oh, wait. I thought it said "Ass Clown.")

Class Psychopath

(If he's violent, give him my e-mail address. I'm always looking for a vicious henchman.)

Favorite Teachers

(Sun Tzu, Niccolo Machiavelli)

Favorite Subjects

*(Covert Paramilitary Tactics, Advanced
Interrogation Techniques, Horsing
Around in the Showers)*

Toughest Professors

(Boo-hoo. In my day, teachers used to slap you across the palm with a ruler and scald you with hot tea if you botched an arithmetic problem.)

Creepiest Professors

(Yes, Mr. Overweight Asthmatic AP Biology Teacher Who Spends Way Too Much Time Shooting Photographs of the Girls' Field Hockey Team with His PhotoZoom Lens, I'm talking to you.)

Put me through to Gabe Kotter!

Best Grades _____

(Way to go, Jimmy Neutron!)

Worst Grades _____

(Helpful hint: When you feel pressure, release the Q-tip.)

Class Genius _____

(He's pretty clever, eh? Give him my e-mail address, too. You can never have too many biochemical engineers.)

Note to self: future recruit in the war against Lois.

MASH

Future Husband/Wife

1. ~~Jennifer Garner~~
2. ~~The Lovely Liddane~~
3. Leslie Stahl
4. Rupert (we made a deal that if we're both single at forty...)

Future Car

1. ~~Mini Cooper~~
2. Volkswagen Cabriolet
3. Sherman Tank
4. ~~Mazda Miata~~

Future Occupation

1. ~~Emperor for life of all mankind~~
2. ~~Choreographer~~
3. ~~Professional assassin~~
4. Movie star/scientologist

City of Residence

1. ~~San Francisco~~
2. ~~West Hollywood~~
3. Prague
4. ~~Quahog~~

MASH
(Mansion, Apartment, Shack, House)

oh, boy! I love this game! Yay!

Instructions: *Fill in four choices for each of the following categories. Then, roll a die or pick a number between 1 and 6. Using that number, start counting at the M in MASH and go through all your choices. Each time you come to that number, cross out the choice that you landed on. When there is only one choice left in each category, those are your divine fortunes.*

Future Husband/Wife

1. _____ 3. _____

2. _____ 4. _____

Future Car

1. _____ 3. _____

2. _____ 4. _____

Future Occupation

1. _____ 3. _____

2. _____ 4. _____

MASH
(Mansion, Apartment, Shack, House)

City of Residence

1. _____ 3. _____

2. _____ 4. _____

Number of Children

1. _____ 3. _____

2. _____ 4. _____

Number of Times a Week You Have Sexual Intercourse (Hee-hee!)

1. _____ 3. _____

2. _____ 4. _____

Spouse's Occupation

1. _____ 3. _____

2. _____ 4. _____

MASH

(Mansion, Apartment, Shack, House)

Location of Vacation Home

1. _____ 3. _____

2. _____ 4. _____

Potential Mistress/Mister (Oooh, saucy!)

1. _____ 3. _____

2. _____ 4. _____

Lasting Legacy for Mankind

1. _____ 3. _____

2. _____ 4. _____

Yacht, Butler, Pool, Hovercraft
(Which one will you get?)

1. _____ 3. _____

2. _____ 4. _____

Best Hair-of-the-Dog Recipes

(Of course, I myself am partial to a glass of Chablis or a nice Creme de Menthe.)

Bloody Bull

1 oz. vodka
½ glass tomato juice
½ glass beef bouillon
2 pinches of celery salt
1 dollop of horseradish
1 slice of lime
1 lemon wedge

WARNING: Must be Twenty-one or older to try this!

Class Lush

Class Bimbo

Class Mimbo

Awful lot of Nobel laureates on this page.

47

Greatest
Nemesis _____

*(A certain nasal-voiced, red-headed shrew whose ovarian
Bastille I erupted from nearly a year and a half ago)*

Most Memorable
Grudge Matches

In Sports _____
*(The Newport Red Stockings vs.
The Providence Lurching Dutchmen)*

In Academics _____
(Watson vs. Crick)

In Love _____
(Ike vs. Tina)

Other _____
(Joe vs. The Volcano)

Most Likely
to Succeed

Most Likely to
Spend His Life
Mired in a Dead-End
Middle-Management
Job Until He Finally
Snaps and Swallows
a Jug of Liquid
Laundry Detergent

Most Likely to Become the Leader of a Rural, Antitechnology, Pro-Bigamy Religious Cult

Best Ideas You've Ever Had

(Laced Lois's oatmeal with yak pee)

Worst Ideas You've Ever Had

(Put three raisins up my nose and never saw them again)

Best Inventions of the Year

(Brain neuralizer—all the convenience of mind control with none of the hassle of messy serums)

Worst Inventions of the Year

(Drill bit—mounted hovercraft—forgot to include an emergency shutoff device to prevent me from blacking out due to excessive g-force)

Worst Fears

(Thirty more years of estrogenical tyranny)

Most Embarrassing Moment

(When Peter refused to clean my diaper)

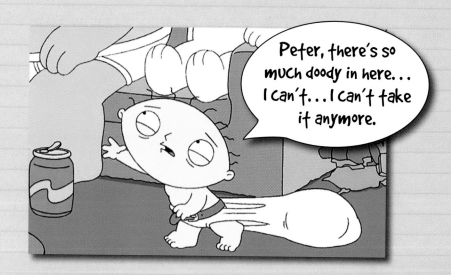

Second Most Embarrassing Moment

(My little faux pas from Pamela and Tommy Lee's dinner party)

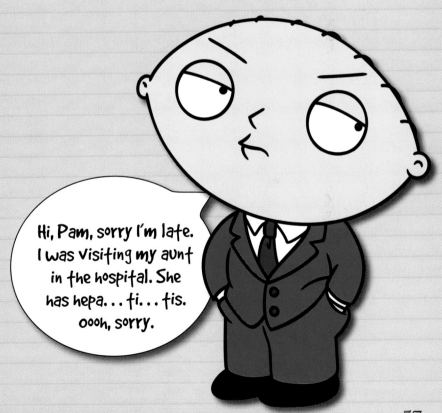

Best Cover-Ups/Excuses

(It was a wardrobe malfunction, I didn't inhale,
and I was suffering from "exhaustion")

A SPEECH IMPEDIMENT.

Well there Ms. Phi Beta Kappa/Mr. Summa cum Laude, you've done nothing thus far but convince me that higher education has made you a potty-mouthed, sex-crazed hooligan tarting your way across town, with gin on your breath and depravity on your mind. But, if you truly are the mature graduate you claim to be, prove it by acing this one final test. And no cheating! For every time you cheat, I shall kill you! — Stewie

TEST OF CHARACTER

1. Have you ever stayed up all night to help a friend study for a final exam?

❏ Yes ❏ No ❏ Smoked Too Much "Doobage" to Recall

2. Have you ever plagiarized material to complete a term paper or essay test? (And yes, mimeographing a page out of the *World Book* does count.)

❏ Yes ❏ No ❏ Inhaled Too Many Whip-Its to Recall

3. Have you ever dated your best friend's girlfriend or boyfriend?

❏ Yes ❏ No ❏ Whored About Too Much to Recall

4. Have you successfully played matchmaker between two friends?

❏ Yes ❏ No ❏ Way Too Self-Absorbed to Even Care

5. Have you ever asked someone to the prom simply because you knew they couldn't get a date (and would therefore most definitely "put out")?

❏ Yes ❏ No ❏ Drank Too Much Boone's Farm Strawberry Hill Wine to Recall

6. Have you ever sent your parents a care package instead of expecting one from them?

❏ Yes ❏ No ❏ I'm an Orphan, Thanks for Rubbing It in, You Wicked Baby

7. Have you ever slept with a teacher for a good grade?

❏ Yes ❏ No ❏ Can't Recall Due to Short-Term Memory Loss Caused by Advanced Syphilis

8. Have you ever held a friend's hair whilst they vomited?

❏ Yes ❏ No ❏ Can't Recall Due to Shock Caused by Them Puking in My Fav Pair of Manolo Blahniks

9. Have you ever helped a pledge you knew was in over his/her head?

❏ Yes ❏ No ❏ Paddled Too Much Freshman Ass to Recall

10. Have you ever stolen from your roommate and/or monopolized one of his/her possessions?

❏ Yes ❏ No ❏ Smoked Too Much of My Roommate's "Doobage" to Recall

Bonus question worth fifty points: Have you ever met anyone who repaid their student loans in full?

Scorecard

If you answered yes to five or more of the above questions, then you're either a mensch, a rube, or a complete jerk. You're a graduate now—you do the math.

If you answered Can't Recall to five or more of the above questions, then you're either brain dead or a massive delinquent. Either way, you should seek a job with the government.

And if you answered yes to the bonus question, I hope the suckers were your parents, and they'll pick up the tab for you, too!

Advice for Formal Affairs

Run If:

Your date bears any resemblance to this cretin

He utters the gibberish catchphrase "Giggity, giggity, giggity"

He's a forty-year-old virgin

She's a sixteen-year-old virgin

That's what I love about high school girls. I keep getting older, but they stay the same age. Yes they do, yes they do.

Graduation Day Etiquette

Do's

DO arrive at the commencement ceremonies on time. You may have slept through every class scheduled before noon throughout your entire academic career, but from this day forward admirable punctuality will be essential to your plans for world domination. After all, you know what they said about Mussolini and the trains. You don't? Well, I guess you slept through that European history class, eh?

DO wait for your name to be called before rushing the dean for your diploma. Nothing like grabbing Chien-Ming Wang's diploma when your name is Brian Wiggins.

DO toss your cap up into the air after the whole charade has ended. Such ritual practices are a metaphor for "tossing your hat into the ring" and are absolutely necessary for letting potential employers and sodomites know that you'll do "anything" to succeed.

Don'ts

DON'T moon the audience. As delightful as it may feel at the moment, photos of your pale, freckled ass are likely to circulate on the Internet forever. And there goes your shot at ever being "The Next American Idol."

DON'T write "Hi Mom" on your cap. Such tomfoolery is reserved for chance appearances on televised sporting events. Graduation is a rite of passage not a soccer melee.

DON'T make rabbit ears behind the B-list celebrity the school has procured as a commencement speaker. He may be insufferable, but this is not what Brian Dennehy signed up for.

Biggest Public Faux Pas of the Year

(Tom Cruise climbs the Empire State Building, Oprah Winfrey in hand, and swats at passing biplanes)

Biggest Movie Bombs of the Year *(Taxi 2: Electric Boogaloo)*

Other Memorable Stinkers *(The Fat Man's blowhole, post beans)*

TIP: *If you feel you must let one rip during the graduation ceremony, or at any other time in your adult life, be sure it's lethal enough to disable any and all witnesses. If not, look incriminatingly at your most reviled adversary.*

Favorite Band

(Stewie and the Cow-Tones)

Favorite Blog

(loismustdie.blogspot.com)

Favorite Movie Star

(Stewart Gilligan Griffin)

Favorite TV Show

(Three-way tie between Family Guy, The O.C., *and* Charlie Rose—*he is so freaking erudite, it's insane)*

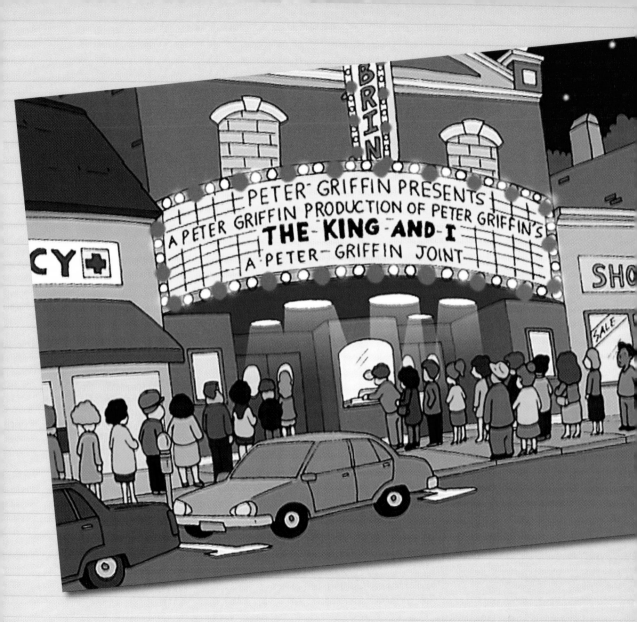

School Plays

(The Pajama Game, Guys and Dolls, From Justin to Kelly)

Best in Show

(Doris Day as "Babe Williams")

Worst in Show

(Justin Guarini as "Justin"—ugh, that hair, it looks like it came from below the belt)

Memorable Flubs

(When Stubby Kaye stepped on Frank Sinatra's line, and Frank punched him in the throat)

What the Critics Had to Say

(Who cares? They're all jealous hacks who only wish they could hold a candle to the incomparable Doris Day.)

Best Party of the Year

(Really? I wasn't invited. Ouch.)

Worst Party of the Year

(Yeah, seriously, what a stinker. It was like watching paint dry. . . . Okay, I've got to be honest with you, I wasn't invited to that one either, and my pride is really starting to hurt about now.)

Biggest Partier

(I'm gonna sit this one out and sulk a little)

What's in Your Closet?

Fact

(Okay, I'm back. Scrolls of blueprints for nefarious devices, a miniature spacecraft for traveling in the Fat Man's body, and weapons-grade plutonium.)

Fiction

(Alphabet blocks, Richard Scarry books, and footy pajamas)

Fantasy

(Scarlett Johansson. Va-va-voom!)

THERE'S AN EVIL

MONKEY IN MY CLOSET!

Best Gossip

(I heard that after Brad and Angelina adopt those Thai babies, they eat them)

Team Records

(Yeah, not really a team sports guy)

Personal Athletic Achievements

(6.0 in Floor Exercise, 5.8 in Rhythmic Gymnastics)

Highest GPA for a Semester

(Yech, that's even worse than President Bush!)

Most Consecutive Nights Inebriated

(Well, that accounts for the minuscule GPA)

Others

Hottest Hook-Up

(Janet—we shared cookies, and it was magical)

Lamest Hook-Up

(Liddane—I tried to grab her boob, and she slapped me. . . . Then, I wept.)

81

Things You're Itching to Do After Graduation

(Backpack across Europe, grow a goatee, write the great American Choose Your Own Adventure novel)

SO GOOD!!

Couples Most Likely to Marry Right After Graduation

❏ *Due to unplanned pregnancy caused by drunken tryst and broken condom*

❏ *Due to pure love (and utter stupidity)*

careful there, Paco—your significant other is libel to read this page.

Rules to Live By

(Such as "don't wear brown shoes with a black belt"
or "if you love something, set it free")

A MARTINI A DAY KEEPS THE FLEAS AWAY

Salutations to Avoid

(Or use—depending upon your relationship with the individual in question)

When Signing Someone Else's Slam Book

Kiss off you swine-breathed lox. I never liked you anyway.

You sick little moo cow. Please wash your hands
before touching my grad pad.

So, tell me. Is there any tread left on the tires at all?
or at this point would it be like throwing
a hotdog down a hallway?

I'd love to write you a longer note, but you're a total bitch.

Hey, so this is awkward, seeing as we've known each
other for four years, but I've been meaning to ask you—
are your parents by any chance first cousins?

Have a great summer! And burn in hell!

Most Painful Memories

(Oh, yeah . . . that's it . . . cry for Stewie)

Most Repressed Memories

(Show me on the doll where the bad man touched you)

Most Joyous Memories

(Blah, blah. Who the bloody hell cares?)

The Most Demented Prank You've Ever Pulled on Someone Else

(I truly hope that somehow, somewhere, Lorena Bobbit is filling this out right now)

The Most Demented Prank Anyone Has Ever Pulled on You

(Ditto for her ex-husband, John)

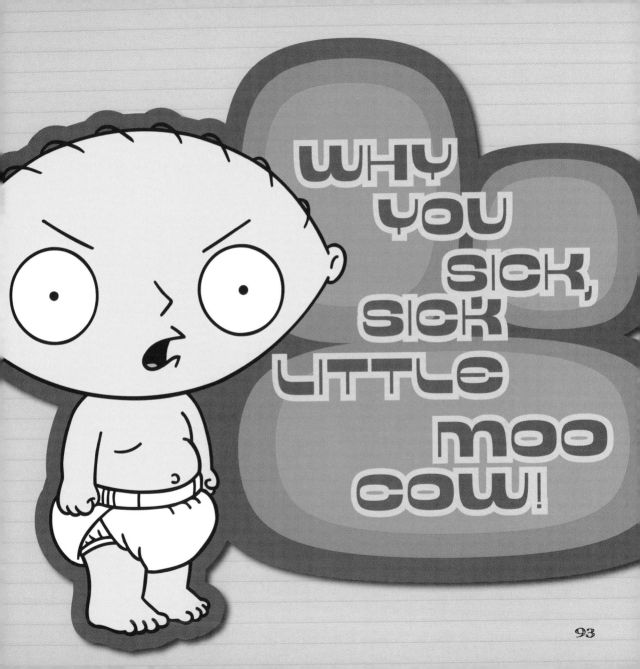

Future Travel Plans

(I'm going to Rio de Janeiro for Carnival!)

Private Thoughts

("Kissed my first girl. Lost my first patient.
Life will never be the same. . . . " Eh, I cheated.
I stole that one from Doogie Howser.)

Freaky Habits to Break

(Dependency on the maternal teat)

Freaky Habits Worth Keeping

(Shooting poisoned darts at the wretched hag)

Miscellaneous Confessions

(Dear diary, I can't shake the feeling that I'm a dirty flirt, and I want it bad, and I don't care who I get it from, because I have no self-respect, and that gets me off . . .)

I've been a bawdy

Possible Professions to Pursue

(Gun running, espionage, global tyranny . . .)

there's treachery afoot!

Blueprint for My Future

Goals

(Vanquish Lois, conquer the planet, learn to use the potty)

Ideals

(Survival of the fittest, fortune favors the bold, there's no business like show business)

Plans for How to Get There

(Top secret. Nice try, though.)

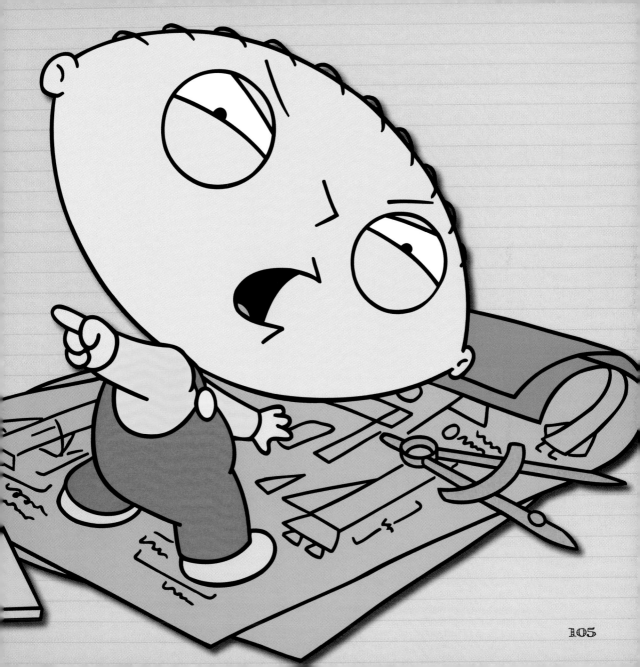

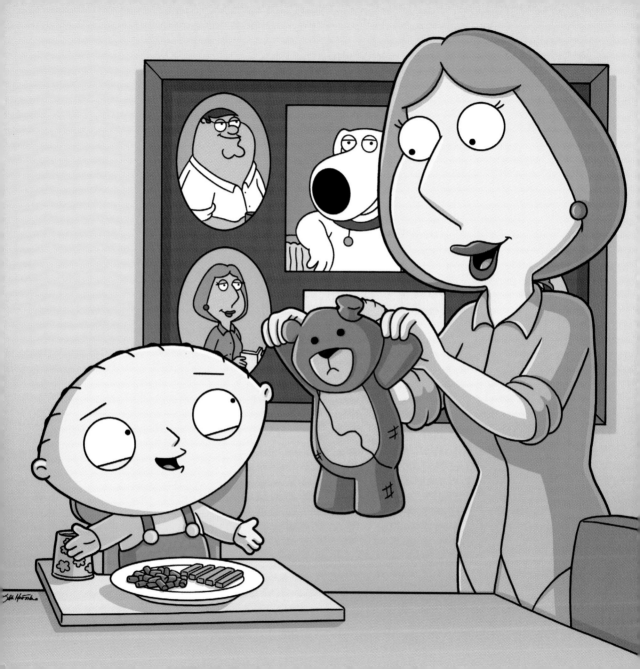

Parent Report Card

Ponied up for tuition, expenses, and bail

❏ Pass ❏ Fail

Offered sound advice when needed (and kept their yaps shut the rest of the time)

❏ Pass ❏ Fail

Endured graduation ceremony, in spite of excessive heat and insane boredom

❏ Pass ❏ Fail

Threw a graduation party (extra credit for kegs of beer and Jenga tourneys)

❏ Pass ❏ Fail

Made you a partner in their business (like Fred Sanford or that ridiculous television bounty hunter who wears leather pants, mirrored sunglasses, and vests with no shirts)

❏ Pass ❏ Fail

Whether they passed or failed check here if you love the deadeyed dullards anyway

❏ Pass ❏ Fail

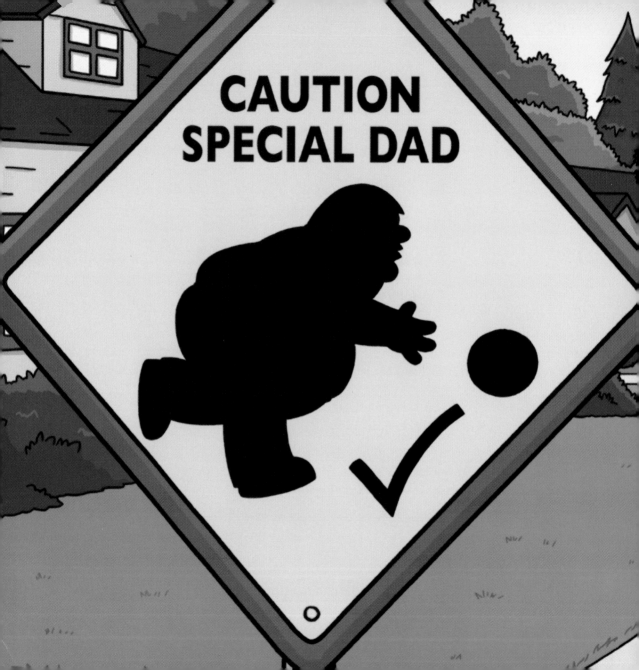

Message Page

(Because your parents are clearly "special" too, this message page is reserved just for them. [Seriously, you see what I have to deal with on a daily basis, how bad could your parents possibly be?])

Final Farewells

(Goodbye, good luck, and burn in hell!)